To My Family

Happiness lies within you;
enjoy the journey, and reach for the stars

TABLE OF CONTENTS

The Spirit of Jens Jensen

In the silence of winter
 the Council Ring is quieted from the activity of visitors;
 woodland creatures peacefully roam throughout the swale,
 and the land is hushed except for Mother Nature's wail

Snow covers the paths that lead to the water's edge;
 the spirit of Jens Jensen appears;
 he wanders throughout the woods at the Clearing
 and pauses briefly, overlooking the bluff

Turning, he kneels to light a campfire in the ring of stone;
 smoke swirls upward in the midnight air,
 on this clear crisp night…it can be seen for miles from across the bay

He sits close to the limestone circle, warming himself by the fire;
 descendants of the past come to assemble
 on the asymmetrical spheres

Lighthearted chatter echoes in the night, as they prepare the evening meal;
 some believe their voices are only the blustery wind in the trees;
 with bellies full, they reminisce about days gone by and…smile

The ancestors are proud they provided a legacy
 for other generations to explore,
 this peaceful land in Ellison Bay

In the early morning dawn, a smoldering campfire remains;
 the only evidence of his existences are footprints in the snow;
 he knows others will follow to protect this sacred ground
 and his spirit will rest well on the shores of Green Bay

Things my mother should have told me . . .

- That being a woman is comparable to a man, but there are differences in compassion and understanding.
- Abuse is not a part of the equation in a relationship.
- Don't look at menstruation as a curse; look at it as a cleansing of a woman's soul.
- When you lock a door, don't throw away the key; you never know when opportunity will knock.
- Choose your battles wisely.
- Pray and pray often.
- That having a baby would bring so many joyful moments.
- Own a pet before you have children. You will learn about unconditional love.
- The difficulty of letting go is part of God's plan.
- Take an early morning walk just as the crimson sun rises. It will leave a spectacular photograph in your mind.
- How this phrase "use it up, wear it out, make it last, do without" – are words to live by.
- Watch the sun set with the one you love; you will see that the sky is filled with a kaleidoscope of colors.
- Saying goodbye to friends is a difficult thing to do.
- To find the love of a good man is something to cherish.
- Finding the beautiful person inside takes quiet thought, reasoning, and reflection.
- Enjoy a peaceful moment called…solitude.
- Never take more than what you need. Always return what you don't need.
- Becoming a mother is God's gift to you; and becoming a grandmother is God's infinite reward for a life filled with love.
- Be a firm, understanding woman…forgive, forget, and move on with life.
- Earning a college degree is priceless.

A Picture is Worth a Thousand Words

The past couple months have been more challenging than any undertaking I've had to endure. I've always kept a clean and tidy house, yet, from time to time, things got overlooked. Now that there's plenty of time on my hands, in part to the pandemic quarantine, I decided to go through cupboards and closets to see what was really needed and what could be discarded. After moving things from one place to another, I found my camera. It had been stored in my office waiting for just the right moment to take pictures.

When the cooler-than-normal April turned into a still cool May, my dog and I began taking walks. Not just our normal morning walk; we walked three times a day. I'm lucky that we have sidewalks to walk on, but I also remember being able to walk on country roads enjoying the first signs of spring.

I began taking pictures with my 35mm camera. They are not pictures that will ever win a contest. They are just pictures of birds, animals, and flowers that I can look at from time to time to remind me how beautiful the earth is.

The robins arrived early in March and shivered their way through the month and into April. I saw the return of the red-winged blackbirds and the exit of the chickadees. In May, I checked the pond where we live for the return of the great blue heron and, most recently, caught a rare sighting of a common crane. For days I didn't see these magnificent birds. I did see a family of ducks swimming in the pond who were enjoying the peaceful quiet of their solitude

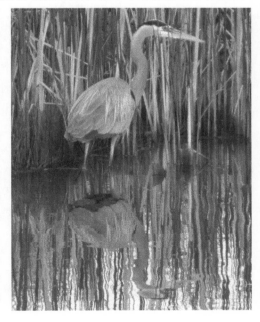

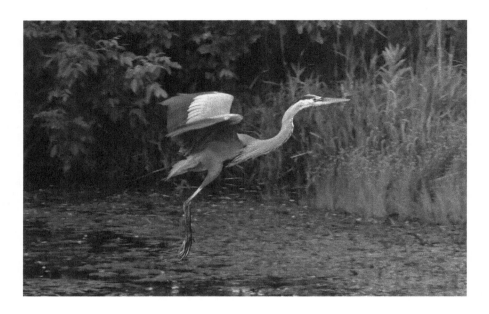

with eleven offspring. One day they were gone. I hoped they moved on to a different pond, but it didn't take long before a family of geese and their three young ones quietly swam in the pond. Another day they, too, moved on. I silently prayed they were safe. The next week, I saw a flock of geese cross the village street. Not only were there a dozen adult geese, there were several small goslings. What amazed me was that while the flock walked across the street toward a different pond, the goslings lagged behind and one adult goose stood tall and proud behind the young ones, waiting patiently for them to cross. The lone goose made sure all had crossed before making its way to the pond.

The following morning, my dog and I walked very early. The sunrise was spectacular; an orange glow filling the eastern horizon. We walked past the pond, and I saw a common crane standing quietly in the water. I hurried home to get my camera and returned to the pond, hoping it didn't take flight before I made it back there. I tiptoed ever so quietly so as not to scare this great bird. I stood for quite some time leaning against a small maple tree, snapping pictures and waiting for just the right light to hit the water. The bird became restless, and I knew it was time to leave. I captured a picture of

him and his reflection in the water. As I left, I smiled. I knew there would be other days when I could get just the right scene.

As I walked away, I felt a sense of relief. While the world seems chaotic, Mother Nature in all her infinite wisdom has maintained a normalcy to the Earth's cycle that all is well. The sky appeared bluer, cleaner, clearer. I could actually hear each bird sing its marvelous symphony. I realized that I can't change what's going on in the world, but I can appreciate all the goodness there is by preserving some of the beauty in a mere photograph, because as the saying goes, "A picture is worth a thousand words."

A Wedding Cup of Tea

Grandmother's china teacup sat on the cupboard shelf for fifty years. No one was ever allowed to use the cup. She was afraid it would get broken. It had been a wedding present from her great-grandmother on her wedding day.

One day, the cup was carefully removed from the confines of the oak cupboard. It was gently washed in soapy suds and then dried with a soft, white linen towel. The teacup was gently placed on the trestle table, while hot steaming water simmered in the white porcelain teapot on the old gas stove.

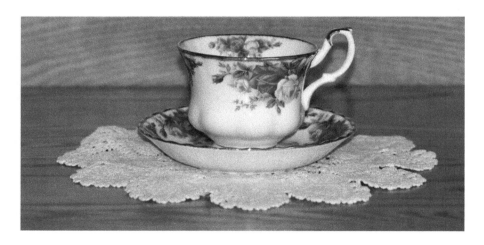

When the kettle whistle reached a high pitch, the teapot was lifted from the burner. In anticipation of the baptism of the cup, peppermint tea leaves waited in a heap at the bottom of the tea strainer for the first blessing of water. Steaming water was carefully poured into the cup. The tea was brewed.

After a few minutes, the aromatic tea was ready to sip by soft, delicate lips. The gentle hand of the woman slowly lifted the cup to her mouth. Before taking a sip of the steaming brew, she raised the cup to admire the beauty of the red, pink, and yellow rosebuds that etched the rim. She thought of all the times her grandmother's hand had reached for this cup in the cupboard, but bypassed it to take an old cup for her tea.

The second blessing came when she drank the aromatic herbal tea. Prayerfully, she remembered all women who had passed through life wanting to reach for this cup, but left empty-handed because they were told never to use the antique teacup.

The young woman dared to take the china cup from the cupboard, washed it with suds, dried it with white linen, and steeped a cup of herbal tea to caress her spirit and soothe her soul. She took a stance for all women who only admired the china teacup and wished they had used it for themselves.

As the young woman gazed out the window, she recalled weddings of the past and raised her cup again to toast weddings of the future. She knew that all women are a blessing, like a warm cup of herbal tea that is served in a fine china teacup.

Winter's Cold Wind

(Published in the 2005 Wisconsin Fellowship of Poets Calendar)

January's blast of bitter winter winds
 sends a shiver from the tip of my nose to the end of my toes

Snowflakes falling by the millions to the ground
 covering rooftops and tree branches
 their softness so white, my heartbeat quickens and dances

Doves and chickadees huddled precariously at the feeder
 oblivious to the snowflakes that dampen the seed

Two gray squirrels scurry over the icy road
 running for protection from the frigid cold

Wooden cedar swing sits idle on the white-carpeted lawn
 no one to swing, listening only to winter's song

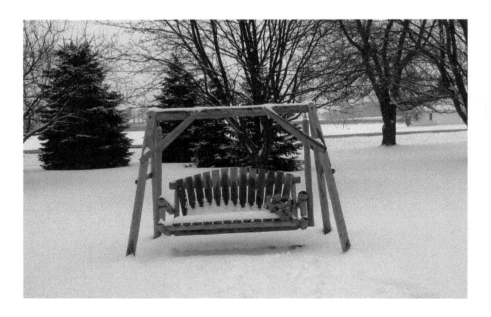

Following Mother Nature's Path

When I became a Reiki Master, I discovered the difference between nature and nurture. Nature has an effect on our intellectual and physical health, while nurture has an effect on our natural and inherent tendencies to learn from our environment. I begin each day making coffee, feeding my pets, and taking a walk with my dog. I make coffee first so when I get home, I am greeted by the earthy aroma when I walk through the door.

As a child, I would huddle under my blankets during severe thunderstorms. The F4 tornado that hit Port Washington, Wisconsin in the 1970s made me aware of Mother Nature's power, and ever since that day, when storms were predicted, I learned to watch the birds for signs of impending danger. On very still days, when the birds stopped singing and hid in the trees, I knew to take in the laundry and kept my children close to the house. We sometimes had to take refuge in the basement just in case another tornado struck. On those days, I wondered why Mother Nature was so angry.

It was after my children grew up and moved on to raise their own families when I began daily prayers; yes, I prayed before they left home, but my life was busy with the children and most nights I'd fall into bed exhausted from the day's activities. I wish I would have had a few more moments to dedicate a smidge of time to meditation. Now, I find praying during daily walks makes me closer to our Creator and to nature. I've always

loved being outside and working in my gardens, camping at state parks with my family, but walking each day gives me renewed energy.

Every day, I get up early, just in time to see the stars highlighting the darkness of morning. On these walks, I make sure to look up at the sky, and most often I feel privileged to see the glorious sun rising on the eastern horizon. In spring, I sometimes get a glimpse of the robins returning to our yard. I have even witnessed sandhill cranes flying ever so gracefully just above the rooftops and the stately great blue heron resting peacefully in the pond, waiting for his breakfast to emerge from its depths.

Each day, I wake early to walk my dog, pray, and meditate. These walks are mostly around the park where I live, but when I get a chance to visit a state park in the Kettle Moraine Forest, I find that's where I commune best with nature. I enjoy walking on the trails, looking up to see a variety of birds migrating in the fall or seeing constellations at night, glistening in the sky, and the ever-glorious supermoons that appear every so often where I live in Wisconsin. I enjoy the ever-changing seasons: frosty weather to cool spring days, warm, humid nights of summer to colorful panoramic views in autumn. I've seen the oceans on the west and east coast, watched sharks jump in the tumultuous ocean of the intercoastal waters of Singer Island, Florida, and watched the graceful manatee swim along its edge. I find contentment praying in wide-open spaces, and watching the man in the moon. Mother Nature and I have a lot in common; we are free spirits.

Jack and George

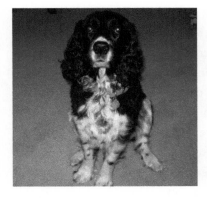 After a short illness, we lost our rescued animal companion, Jack. We adopted him when he was six years old from an English springer spaniel rescue group, only we didn't know he was very ill. The first time we brought this dog home, he jumped into a snowbank; all the while, his tail wagged. I thought he found a critter underneath the snow, but he just loved to play in the white mounds that filled our yard. When he brought up his head, it was covered with ice crystals. I immediately changed his name from Junior to Jack Frost. I believe to this day that he liked his new name. It didn't take him long before he adjusted to life in our house.

He liked being able to sleep upstairs in the living room rather than sleeping in the basement, where his previous owner had kept him during the winter months. He enjoyed our three-mile walks, that is, until one early winter morning. When I went to get his leash, Jack looked at me and decided he didn't want to walk. I figured it was too cold for him and went for a walk alone. It felt strange at first walking without him. During the week, he began to distance himself from the family. He didn't sleep next to my bed and began eating less.

We made a trip to the veterinarian's office and ran blood tests. They came back inconclusive. But in my gut, I felt something was wrong. Late one evening, my gray cat, Ashes, meowed rather loudly during the night. I went downstairs to find Jack in respiratory distress. He woke when I caressed his soft fur. I spoke gently to him. "What's wrong, boy?" He could hardly pick up his head.

By seven in the morning, I managed to get Jack in the car, and we drove to the emergency veterinarian's office. It was a Saturday morning, and our local

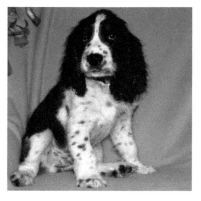

vet's office was closed. Jack slowly walked into the office, but needed to lie down. The kindly doctor took him in the back to run more tests and soon brought him back into the room where I waited. A sick feeling of dread filled my heart. The technician put a blanket on the floor, and I sat down next to Jack. I prayed over him, prayed that the animal spirit guide would help this lovely dog. Tears welled in my eyes, and I could hardly see. I didn't want to scare Jack so I looked away to regain my composure. I spoke to Jack, my voice quivering. "I'm going to take off your collars so you are more comfortable." This must have been a sign for him. He picked up his head, looked me in the eye, and ever so gently his head fell onto my arm. I slid my arm out from under his head and put it to rest on the blanket. I ran out of the room to get the veterinarian. When he came back, he confirmed that Jack had passed onto the Rainbow Bridge. While death is unpleasant, Jack passed away peacefully in my arms. Our family was saddened by the loss of this dog. The grief had been overwhelming. A month later, we left for Florida without our friend and animal companion. I hardly noticed the scenery as we drove through different states. Even thinking about Jack made my eyes tear up.

Our house always had the pitter-patter of four paws on the floor, so it came as no surprise when a breeder from Wisconsin replied to my email two months later to adopt one of her English springer puppies. It would take another four weeks before we returned home, and she didn't want to wait for us. I felt disappointed that we couldn't get a puppy right away, but a couple weeks later, she asked if we'd be interested in adopting one of her ten-month-old dogs that had been returned to her.

When I saw George's picture, my heart leapt for joy. He had a certain look in his eyes that said "Please, adopt me." A few days later, we headed back to Wisconsin from Florida. The drive took two and half days, and like always, the drive home seemed endless. At least I had something to look forward to. The clock ticked away each minute, each hour, and each day.

Before we unpacked our suitcases, we drove to Sheboygan to meet this dog. I liked his markings; he was a tri-color: black, brown, and white. But when he saw my husband, he cowered away. I sat on the floor next to him, and he came next to me. I've always had a way with dogs so it came as no surprise that we brought George home. Little did we know that George had severe anxiety issues. At first, I didn't pick up on the dog's anxiety and figured he felt fearful to go to another new home.

We brought George to our old house, and he settled in. We didn't know he had many fears, especially of cars, trucks, garbage dumpsters... noises. Then we did the unthinkable; we moved from our old house into a condominium. This may have been the worst thing to do for George as it upset his confidence and stability.

Moving days are always hectic. We moved from a two-story house into a one-story condo. In order to keep the dog and cat safe, we put them in separate bathrooms. When the movers finished unloading the boxes and furniture, we let the dog and cat out to explore their new house. George looked like he was overheated. As I walked through the house, I noticed the thermostat had been set to 75 degrees. I didn't understand why the previous owner set the thermostat up. After drinking water and letting him out to sit in the shade under the pine tree, George cooled down. By this time, we all needed a break.

It took a week to get settled. Everything seemed to go well, at first. A few days later, we left George alone in the condo and came home to find that he had defecated on the rug in more than one place. I believe this was his way of saying he wasn't happy that we left, and perhaps he felt abandoned. After two more episodes, we learned not to let him have the run of the house. I read somewhere online that by leaving a television on while you are gone, pets will feel safe. We put George in our bedroom and put the television on. When we came home, he seemed calmer and didn't have any accidents. This went on for two years, and we finally were able to give him the run of the house when we left for errands, as long as we left the TV on.

Two years later, I discovered George had hip dysplasia. He had an incident in the park where another dog walker let his dog get too close

and the leash wrapped around George's back legs. When we got home after our walk, George had difficulty jumping up on his favorite spot on the loveseat. The next day, I took him for a vet check. The X-ray revealed he had hip dysplasia. Hip dysplasia is commonly found in English springer spaniels. After reviewing the care plan with our vet, George recovered from the sprain. He still has hip dysplasia and is being monitored for changes. It's now five years later; the winter and cold springs seems to make his condition worse, but he still enjoys walks.

Of Cocoons and Butterflies

Fall ended with sadness in our family late last year. My husband's younger brother, Edward, lost his battle with prostate cancer. Not only was our grief profound, I came down with writer's laryngitis. Each day I sat at the computer and stared at a blank screen. So, I busied myself with closing down the gardens. It seemed to take forever to decide if I should save the scented geraniums or throw them in the compost pile. I ended up taking them into the basement and put them under the grow light.

With the onset of winter, I wrapped myself in a colorful quilt and became a recluse. I only ventured outdoors to shop, and anxiously returned to the safe haven of my cocoon. I definitely had a mental block for writing. Eventually, I came down with a terrible virus and lost my voice for three weeks. Christmas Eve mass was a disappointment because I could not sing "Ave Maria," "Silent Night," or the other carols that brightened the season. I felt like a butterfly that had its wings clipped.

I remember reading somewhere that it's better not to dwell on an illness. A person should get up each day and face the world as if they were not ill. I tried to focus not on my silence, but on the beauty of the snow. After all, a blank page isn't that bad! And there's a song that says *"Silence is Golden."* Slowly, after Christmas, I felt my strength return. I folded the quilt and put it on the back of the wicker loveseat in my office. I forced myself to emerge from the dark depths of my solace. I've always felt comfort working in the garden, but it was the beginning of winter. My gardens were under several inches of pure white, glistening snow. Then I remembered the potted plants I brought in the house in November. It was time to see if they survived the transition from outside to living inside under the grow light. The strong stems of the orange scented geranium gave me hope, and for a moment I forgot that I couldn't speak or sing. I forgot that I couldn't find the words to put on paper.

I picked the dried leaves off the plants and fertilized the soil. I almost heard the plants sigh from the attention they received. When I moved one

of the pots closer to the light, I found a butterfly cocoon hidden under the rim. I was careful not to disturb it. Another gardener told me that if you open a cocoon too soon, the butterfly would not develop and it would most likely die.

Winter is like a cocoon for some people. We wrap quilts around ourselves and hide away until the first signs of warmth. When the time is right, we shed our quilt and emerge new and whole. When I sang "Alleluia" in church the other day, I was thankful that I regained my voice through songs and words. A butterfly emerged early this year, and I look forward to spring with renewed hope.

A Basket Full of Eggs

During the early years of marriage, I learned how to become organized, efficient, proficient, and creative. My husband and I agreed that when we started a family I would stay home with the children; life was hard. We discovered ways to live on one salary, eventually bought a house that was a white elephant, and coped with life's unexpected idiosyncrasies. We made do and did without.

While other women went to their jobs every day, I stayed home with the children. The dollar didn't seem to stretch very far. One child or the other needed eye glasses or braces on their teeth, and for some reason they were always outgrowing their clothes and shoes.

Some days became a juggling act, and there were times when I had all my eggs up in the air at the same time. I realized that I had faded into the wallpaper. My name became *Mom.* If I found a moment to daydream, I probably would have imagined I was a clown in the circus, laughing to keep everyone's spirits up, to make people smile and be happy.

Once, my husband and I went to an office event. I looked forward to connecting with adults, especially college-educated people. After spending 24/7 with children, I craved adult conversation. I thought rubbing elbows with these professionals would inspire me. I knew my husband was held in high esteem in his place of employment. We walked into the room, and my internal alarms sounded. I've always had a great intuition, but this feeling made my stomach flip-flop. He graciously introduced me to some women coworkers and left to get us refreshments. As he walked away, bells and whistles went off in my head. Fear gurgled in my throat and nearly exploded out of my mouth. I wanted to say, "*Wait, don't go!*" But he was gone in a flash. I was a bit unnerved being in front of women, especially his peers.

One woman asked, "What do you do?"

I proudly replied, "I'm a stay-at-home mom." I overlooked the second woman's expression of disdain. The woman who asked the question had the nerve to say, "Oh." She turned, flipped her hair, and both women walked

away. They left me standing alone. I fought back tears and wondered if I should have told them that I was a *domestic engineer* instead of a stay-at-home mom. Would that have made a difference?

After a while, it became easy to put on a façade, a fake happy face. In the future when my husband and I went out, I made sure I had saved enough money to buy one really nice outfit—to be dressed to the *nines,* so to speak. No one ever again knew that I didn't work outside the home. I became very good at pretending life was just fine.

When my youngest child became a junior in high school, I was diagnosed with a life-threatening illness. I didn't know if I would live to see another day. Facing this kind of crisis sent me whirling and spinning. Before, I never had time to think about myself, and now that was all I could think of—*will I die?* My youngest child was in the prime of her high school years, and I couldn't be there for her. Her life, too, was affected by my illness. It took a year of treatment before I realized I would live, or even wanted to; the fatigue, alone, was enough to choke a horse. I had to change my attitude and become more positive. Looking at the cup as half-full instead of half-empty became a way of life. Instead of just saying the cliché, I had to believe it.

The movie *The Bucket List* starring actors Morgan Freeman and Jack Nicholson became a favorite of mine. The movie is about two men dealing with cancer. These men decided to create a list of things to do before they died. I never realized that all my life I had created an imaginary "bucket list." There were things I had wished to do but never believed I could. Now, each time I accomplish one small thing on my list, I say, *"Well, I can check that one off."*

It's easier to appreciate the small things in life. I've learned how to carry a basket of eggs if I didn't fill the basket so full. I've learned it's also easier to juggle boiled eggs than raw eggs. I've learned not to spread myself so thin that I can't take care of myself. Because, if you don't take care of yourself, *who will?*

Summer Haiku

Gray clouds fill the sky this early morning;
rain droplets dampened the earth
wilted flowers sighed with relief
A hint of a rainbow appeared
At first I thought it was a sun dog
Slowly the half arch of pink, yellow, and green
emerged in front of dark clouds

And then . . . Snow in October

And then…it snowed. Not just a few flurries, but seven inches of heavy, wet snow. Come on, it was only October 29ᵗʰ. Halloween was two days away. This year, there would be snow on the pumpkins. The neighborhood kids and our grandchildren would experience an early winter. I rushed around to cover new bushes with garden tents and finish cutting stalks of dried flowers. I made it just in time, too.

When I was a child, snow came up to the windows and didn't leave until after Easter. We didn't own a snowblower, and Dad worked second shift. Mom woke us up around ten to shovel the driveway so he could park the car. Once the mounds of snow were heaped high on the grass, my siblings and I stayed outside to build snow forts and igloos. That particular winter, Dad made an ice skating rink. He would spend days outside pushing the snow into an oval, adding water until he had enough to sustain an icy rink. I learned how to skate and make a figure eight. I dreamt of becoming an Olympic skater, but I never realized the cost and the commitment it would take. My parents only smiled as that dream faded, knowing full well that some people had the talent to skate and some didn't. Dreams are what we base our hopes on; becoming a famous skater was only a fantasy and a darn good one. It helped me to become creative.

This year, I hoped beyond hope that autumn would last longer, even though all summer I noticed the signs of an early winter. The birds left at the beginning of August, caterpillars had heavy wooly coats, and the acorns fell from the trees abundantly.

My husband and I are golfers, and we enjoy being outdoors, especially when the landscape is decorated with beautiful colors of orange, red, and gold. One time, twenty turkeys wandered across the fairway. They weren't bothered by our presence. I took out my iPhone and snapped a few pictures. I'm not sure if the golfers behind us became upset, but it was nature, after all. I had to capture this picture. This year, we got out once a week, but in October, we had to scramble to get in one last game before the weather

turned from fall to winter. The last game didn't improve my golf that much, but I managed to get a double bogey on the first hole. I surprised myself because I didn't shank the ball to the right and managed to keep it sailing down the fairway, missing the sand hazard that was on the right. The first hole is a par five, so when I made the double bogey, I felt very proud. The lessons I learned all summer were to keep my elbow straight, keep my eye on the ball, follow through, and enjoy the game.

Now that outside golf has ended, I've taken to watching it on television. I don't feel too bad when I see the pros on the PGA miss putting the ball into the cup. I certainly have had that experience where the ball is going right to the cup but either clips the edge (because I hit it too hard) or circles around the cup and rolls back out.

While golf can be a frustrating game, it's also a game of patience and a sport I've come to enjoy. One thing I know for sure, next May I will start all over relearning this elusive sport. And then…it will be spring.

Woman with Many Hats

All my major undertakings happened when I tried new things. Some of my adventures didn't pan out the way I wanted, either because I didn't stick to it, or simply didn't have the talent to try and work through it. I learned that some things you are good at, and others, well, I leave that up to the people who are good at them.

In my grandmother's era, she always wore a beautiful hat. That was symbolic of her generation. Wherever she went out, you could tell it was her by her signature black velvet hat and black coat. She raised ten children, cooked, cleaned, and worked in a clothing factory all of her life. I don't remember her ever having a hobby, but with ten children, who had the time?

In my generation, women wear many different hats. They are moms, teachers, doctors, nurses, psychologists, painters, carpenters, gardeners . . . the list goes on and on.

I wanted to become a nurse after high school, but my high school guidance counselor told me I wasn't college material. After high school graduation, I entered the workforce and worked as a file clerk and advanced to a technical publications secretary, learning new technology and trying to find my niche in the workforce. I gained valuable communication skills, word processing skills, and eventually became computer savvy. The many jobs I worked in helped pay the bills and paved the way to the next phase of my life, which was motherhood. Little did I know that by becoming a mom, I would also become a nurse, teacher, psychologist, painter, Mrs. Fix-It (when my husband was away) . . . a Jill-of-all-trades, so to speak because I tried my hand at many different things. I liked staining furniture, and when our children outgrew the crib, I scoured rummage sales for bunk beds, full-sized beds, and dressers. The furniture I found needed repair, and because we lived on one income, I learned how to make it last and do without. I learned how to strip off the old finish, sand, stain, and varnish the replenished wood. This wasn't a bad hobby, but it was time-consuming. It was something I tried but knew would never become a profession.

I tried quilting, but never became good at it. So I began crocheting and counted cross-stitching. I liked the counted cross-stitching best, but a person can have only so many stitching to hang on the wall. When I ended up wearing glasses, I put aside the counted cross-stitching. I went to work after the children were in college, and I learned how to use the Internet. After they graduated from college, I finally attended college, and after graduation slipped quietly into retirement.

I worked in many jobs, and one thing is for sure . . . you will never know if you can accomplish anything unless you try. Never let anyone tell you that you can't do something. With all of my trials and errors, I've become a multitalented woman who has worn many hats.

Early Morning Walk

On a warm summer morning
 when the earth is very still
The crimson sun rises
 just beyond the hill
Yellow finches warble,
 their sweet melody
As red cardinals harmonize
 in the grand oak tree
A white tail deer grazes serenely
 on the outskirts of the swale
The gray rabbit scampers through the corn
There's a peacefulness that is felt
 when I wake early in the morn
It's a gift to see the day emerge
 and be thankful to be born

A Tapestry in the Sky

There was a young woman who was very skillful with her needle and threads. One day, she was summoned to sew a masterpiece for the King of heaven. The woman returned to her room and cried softly. She wasn't so sure she could embroider a pattern that was fit for a King.

The magic silver needle turned to the seamstress and said, "Madame, don't cry...with your soft hands to guide me, we can stitch a magnificent needlepoint for everyone to admire." Suddenly, the woman decided to try. She picked up the magic silver needle and began sewing. As she hummed, the needle responded to her singing, gliding up and down through the beautiful black velvet fabric. With every hand-guided stitch, silver sparkles appeared throughout the cloth. Finally, she was finished. She looked down at her work. A sense of pride filled her with joy.

Never say it can't be done, she thought to herself. *Always have confidence in what you know.* The tapestry became the envy of all mankind and would be admired for centuries.

If you look toward the northern sky on a late autumn evening, you will see the aurora borealis, shining stars, and the brilliant silver moon. The woman designed a tapestry in the sky.

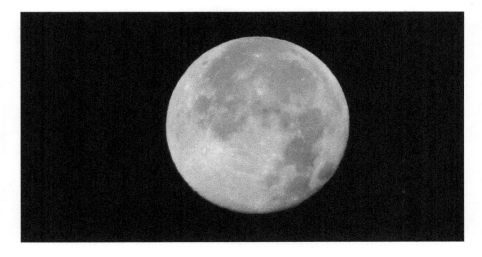

What if . . .

all women formed a sisterhood,
 just like the brotherhood of man

equality would be our motto,
 compassion our steadfast plan

truthfulness and honesty would be our methodology

together we build our self-esteem working hand in hand

we find comfort and compassion when crises erupt

we accept each other for who we are; it didn't matter if
 you were tall, short, heavy, lean or somewhere in between

all women could form a circle encompassing the globe,
 standing hand in hand

we could visualize and accept each other,
 like the common ground we stand

the world would become a better place to obtain equality

we formed a sisterhood for all humanity

Capturing the Moon

In my lifetime, I've tried many different hobbies and worked in many different jobs trying to find my niche. I worked as a contractor instead of in a full-time job mainly because I liked the freedom to work certain hours while raising our children. Sometimes I enjoyed the jobs I worked in, other times it was only a means to an end. I've tried sewing, cross-stitching, even crocheting, but never became really good at any one of them. I liked gardening—feeling the warm soil as I planted seeds and plants…watching the fruits of my labor overfilling a wicker basket in autumn.

I am a woman who literally wears many different hats. I'm unique in that I try something new every so often, just to keep life interesting. I know when I should continue with the venture or simply say, "No, that's not for me."

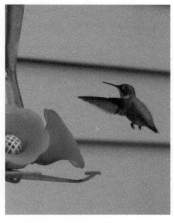

A couple years ago, I found a different hobby—photography. My subjects are mostly birds and flowers. I have a special picture of a hummingbird. With the aid of a zoom lens, I captured him hovering in midair waiting to suckle syrup from the feeder. This colorful bird is remarkable in that he manages to get his drink and quickly flitters off to his nest in a blink of an eye— but once I managed to snap a shot before he left. Each year when spring arrives, I wait patiently to see if he or his cousins return to our area. I call the hummer "Pat" after a dearly departed friend who shared my interest in birds.

There is a great blue heron who likes to rest at the pond near our place. He's not so receptive to having his picture taken, so I have to stand almost motionless waiting for him to come out from behind the reeds. I've managed to take his picture for a couple years, and I'm hoping he will return from his southern home. He flies so effortlessly and quietly. If I didn't look up once in a while, I would miss seeing him flying overhead.

The moon has always fascinated me. I've taken pictures of full moons, Cheshire cat moons, half-moons, and eclipses of the moon. We live in an area where it's pretty dark, except for the occasional yard light. I stand waiting in anticipation of catching the man in the moon, but he's as elusive 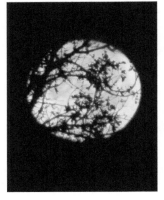 as the hummingbird and as shy as the great blue heron. In fall, when the harvest moon is at its fullest, I put on my sweatshirt, take out my tripod, and set the camera on it. I wait for just the right moment when I can see the lines of the moon and I focus the lens…click, click, and click. I'm done taking pictures before I know it. I go inside to look at the digital frames and select the ones I like the most, deleting a bunch of shots until I find just the right one. The man in the moon seems to smile sometimes. I wonder what he's thinking as he looks down on the earth. The other night, I watched the Cheshire cat moon's half smile. It was so beautiful with the planet Venus almost next to it. I think they were lighting the way for the Big and Little Dippers. I envy anyone with a telescope that can see them more closely.

I admire women who never give up and continue experimenting with different challenges. If we sit still, then nothing will be accomplished. But if we keep trying new things, perhaps one day we will make a difference in our ever-changing world.

Reciprocity in Life

In college, I studied an elective course called "Film as Literature." My professor, Mary Beth Duffey, a soft-spoken woman, taught us how to watch and listen to the movies we viewed.

We watched black-and-white silent films where the actor's facial expressions were most important to tell us how they were feeling—happy, sad, afraid, anxious, or worried. Their body movement also alerted the viewer to changes in a scene to depict whether or not something exciting would happen or something that would bring fear. We learned to watch the credits until the end to acknowledge the actors, producers, film editors, and outtakes.

The sixteen-week journey in "Film as Literature" increased my awareness to the different genres in film. It's no wonder that during the COVID-19 lockdown and social distancing, I watched the movie *Sarah, Plain and Tall* and the sequels *Skylark* and *Winter's End* over and over. These movies were set in the early 1900s when men were dominant and women were subservient. The main characters, Sarah and Jacob, were both strong-willed, which created many challenges when they first met. The hardships they faced together brought them closer together and they learned reciprocity (an equal sharing) of being husband and wife.

Jacob had been a widower for six years when he placed an ad in a paper searching for a woman to make a difference. Sarah, who lived in Maine, answered his ad and came to Kansas to see if she could make a difference for Jacob and his two children, Anna and Caleb. In *Sarah, Plain and Tall*, Sarah learned to work alongside Jacob. He, being a strong-willed man, learned to leave the past behind him and embrace a future with Sarah. He came to love her as well as she loved Jacob. The children looked at Sarah as their mother, but they never called her that out of respect for the woman who gave them birth (she had died in childbirth when Caleb was born).

In *Skylark*, Jacob and Sarah experienced more tragedies. In the first movie, they lost crops to a terrible storm. It could have been a tornado,

but high winds and hail had destroyed their crops and ruined their house and yard. During the second movie, they were facing a terrible drought. Wells went dry, and people had to leave their homestead in order to survive. Dramatic scenes depicted their struggles. One night, heat-lightning caused a prairie fire and they lost their barn. While the house was saved, they were devastated because crops had been ruined by the drought. Jacob convinced Sarah to take the children back to Maine. She did as he requested, even though she felt awful about leaving him alone in Kansas. Her three maiden aunts, called "Unclaimed Treasures," were delightful and charismatic. Sarah, Anna, and Caleb were homesick, but a month later, Jacob came to Maine. He had never seen the ocean before and stood looking out over the cliff. It had finally rained in Kansas, and the wells were once again full of water. Sarah had been asked how long she would stay in Maine. She replied, "Long enough to say goodbye." She knew her place was next to Jacob in Kansas, and there they remained for the rest of their lives.

In the last movie, *Winter's End*, Jacob's father, John, who had abandoned him and his mother when he was a boy, returned to the farm. He had been in the war and worked as a ranch hand throughout his life, but now he had a bad heart. He came back to the farm to die, but not before he could reconnect with his son. In one scene, Jacob broke his leg and couldn't run the farm. Jacob's son, Caleb, and John took over the chores, but only Caleb knew that John had a bad heart. Once again, Jacob, John, and Sarah had a battle of wills, but eventually learned that forgiveness was needed in order for everyone to prosper and move forward.

An old friend once told me that sometimes in a relationship, one person has to give more than the other. It's important not to count how many times you give in order to receive, it's important to appreciate all the goodness… reciprocity in life, an equal sharing.

Polished Shoes

Mother always made sure we had clean, polished shoes. Every week on Saturday night after our bath, she would tuck us in bed and read a story. Afterwards, she would go down to the kitchen and line up all our shoes. She spent hours cleaning off mud, restringing shoelaces, and polishing and buffing a brilliant shine to old leather shoes. The familiar warm melody she sang when she was happy drifted through the house and lulled us to sleep. When she was done polishing all the shoes, a shoe cobbler would have smiled at her handiwork. When we came down to the kitchen for breakfast on Sunday mornings, there, against the wall, were ten pairs of shining leather shoes.

One evening, I couldn't sleep and slipped quietly downstairs to get a drink of water. I paused at the doorway of the kitchen, but did not enter. Something told me to stop. *Funny*, I thought to myself, *it's not Saturday night*. I watched as Mother had lined up all the shoes in the house, from the smallest white pair of baby shoes to father's size twelve black Sunday shoes. I wondered to myself, *what's going on?* At first I couldn't figure out why she was polishing shoes in the middle of the week. Normally, she was happy when she polished shoes. This evening, however, I noticed a change in her demeanor. She didn't sing the happy melody that was familiar to my ears. She sang "Amazing Grace," and as she sang, I noticed tears dripping silently down her rosy cheeks. She reached into the pocket of her apron and pulled out a white handkerchief. She blotted the tears from her eyes and then continued polishing the shoes. It wasn't until the next day, when I overheard her talking to a neighbor, that I realized there had been a death in the family. Never really understanding death and the loss of a loved one, I somehow knew at those moments when Mother was polishing shoes, other than Saturday night, that she was not to be disturbed.

Mother worked like a busy bee around the house, especially during times of sadness. This was the way she dealt with her grief, polishing every pair of shoes until they glowed like the halo from an angel.

Years later, I would understand that those moments of sadness were her way of dealing with loss. I didn't know that one day I would follow in Mother's footsteps and continue this ritual until the day I lost my mother. One day I found myself going to the cupboard for the shoe polishing supplies and lined up every pair of shoes in the house. I buffed and polished each pair of shoes until they looked like new.

For some people, it may seem like an endless, tiresome chore to polish and buff scuffs and nicks out of everyday leather shoes. I found that it's an act of love. Now that I am older, I realize that her silent times were moments when her heart was full of grief but she was able to put her grief aside by singing a familiar melody and polishing old worn shoes to make them look new again. She knew that shiny shoes, no matter what, put a renewed step of confidence in our walk. Even though her heart was full of grief, she still found happiness and gave us a gift from herself. I will treasure all the hours she spent polishing and buffing the old worn leather shoes because I now realize those unspoken moments were very precious times when silence was necessary to heal a grieving heart.

This Gift I Give

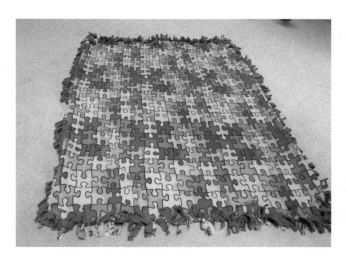

In early October, I started making fleece quilts for our grandchildren. They were easy to make, but time-consuming. At first I didn't remember how to start them. I searched the Internet and found a different way to tie the knots so they wouldn't come apart after washing. For seven weeks, I made six different quilts, one to fit each of the personalities of the six grandchildren. The two granddaughters' quilts had a softer fleece material with butterflies on the front and different color backing. I made them the same, but different. One grandson really likes soccer, so I found navy soccer ball fleece and made his. The other three grandsons like the Brewers, so I made three quilts alike with the Brewers logo, but put their initials on the back so they could tell which one was theirs.

When November rolled around, I made one last quilt for my husband; of course, it was a Green Bay Packers quilt. I told him, "Maybe next year the Pack will do better," cheered on by his using the quilt for warmth. We normally don't exchange gifts, but I was on a roll and wanted something to keep him warm during outdoor soccer games.

With extra time on my hands, at night, I crocheted three infinity scarves for our daughters. I chose the yarn colors carefully to match their chakras

and personalities. Each scarf took about twelve hours to make. And before I knew it, it was a week before Christmas.

I began watching the Hallmark Christmas movies when they first aired in October. Silly, I thought, to watch holiday movies so early. But I looked forward to my favorites. I realized that hidden in these movies was a message, a message of giving to others. Yet as Christmas Day approached, trepidation began creeping up from my inner soul. I wondered if everyone would like the homemade gifts. You know, kids these days are into video games and tablets. I wasn't sure they would like homemade gifts from their grandparents.

Our youngest daughter, Anna, got caught up in the homemade gifting, too. One night, she babysat her nephews and took along a craft for them to make, one for their parents and one for each of us.

We were first to open gifts this year. It was a good lesson for the grandchildren to have to wait. They were squirming around a bit, wishing we would hurry, and we did our best to open our gifts quickly. I opened my package first and found adorable homemade ornaments. The boys had painted an ornament on the outside of mine and a deer face on my husband's. Our daughter filled the inside with white fake snow. They looked like snow globes. You should have seen our grandsons' faces when tears welled in my eyes. I'm such a softy. Their parents opened their homemade ornaments. We laughed when they saw the face of their dog "Daisy" painted on their mom's ornament. Finally, the grandkids could no longer wait. I counted down, "Three, two, one..." and let all the grandchildren open their packaged quilts at the same time. They wrapped them around their shoulders like capes. Our oldest grandson said, "I'm going to use this quilt when I'm reading upstairs." When our daughters opened their scarves, they were very happy, too. I wasn't sure they would like something homemade. Each one has different tastes in apparel. They liked their scarves and wore them on their journey home.

I told everyone these gifts were made with tender loving care, and that when we can't be with them, each time the gifts were used, they were to remember that our arms are wrapped around them.

The apprehension I felt early in December disappeared. Christmas light filled our hearts with love as bright as the star that shines overhead in winter. I'm happy to say we raised our children well and they taught their children that not all gifts have to be bought in a store.

Artesian Well of Hope

The young woman's seasons wintered in her mind
 black was her escape from the bleak snowy existence of life
 she wandered in search of the flowers of spring
 trust was a nonexistent word

Lost...she was lost

Days drifted into years of spirited nights,
 sleeping by day, never to see the sun
 ...or
 feel its fervent rays of assurance
 that no matter what . . . life still goes on

In her despair she cried, "Why me? Why me?"

Feeling her pain, angels' arms reached out in vain
 forever extended – hoping, hoping
 if not to grasp and embrace
 but to nudge her to get beyond the dark abyss

Then, one day, the young woman began her uphill climb
 she felt the warmth of the golden sun on her face
 and listened to the music of the songbirds
 she took a long drink from the artesian well of hope

Pausing she looked deep within her heart
 and discovered the green grass with daisy-filled meadows

She no longer wonders...why me, but now I see

This Too Shall Pass

In 1976, we were faced with a terrible ice storm. We had an eight-month-old baby, and my husband worked on Lincoln Avenue in Milwaukee. On a good day—one way—his drive would take forty-five minutes to an hour. That afternoon, freezing rain stuck to our windows. I could barely see outside. I stood on the porch looking at the roads, heard trees snapping, saw power lines sagging with heavy ice forming on the crossbars. We didn't have cell phones, iPads, or computers, and the only kind of communication happened on the television and through Ma Bell—the telephone. I remember calling my husband to tell him he should get home. At first he didn't think the weather seemed that bad, but in the city, you couldn't see the devastation that was beginning to happen in the country. Around 3:00 p.m., he heeded my advice and began the trek home. It took over two hours to drive down highway 41. Darkness of night began setting in; waiting . . . my heart felt like it was stuck in my throat. I comforted our baby and held her close. I closed doors in our place to keep the heat centralized as much as possible. I moved the crib into the living room. I feared a power outage. We waited. The country roads were treacherous, not only because of the one and a half inches of ice, but because of downed power lines and trees. I sighed loudly when he pulled the car into the driveway. We were together . . .

The next day, we had 49 mph winds that caused more tree damage, and subsequently we lost power. We kept the baby in her crib and covered it with blankets at night to keep her warm. We slept with our clothes and sweatshirts on and cooked on a gas camp stove. Even after my husband made it home, we were not together. He belonged to the fire department, and all the volunteers went to help neighbors, along with WE Energy trucks to open roads to farms, making sure neighbors were warm, had water, and were safe. My daughter and I were alone . . .

Through the decades, people have been faced with pandemics, ice storms, disasters, and whatnot. They've learned to work together, solve the problems, and move forward so that future generations could have a better

life. They stayed busy, and if they didn't have anything to do, they found work to do. When all the disasters ended, people told stories about how they made it through. "That's what built their character."

I learned at a young age never to complain about something I couldn't change, but try to improve my quality of life. When life hands you lemons, you make lemonade. Sometimes I added more sugar to my beverage to make it sweeter. Sometimes I didn't. When storms erupt, either virtually or literally, I find quiet time is a blessing. I can collect my thoughts, find comfort from above, and move forward. I try not to dwell on what I don't have but think about the things I have. We are never really alone if you think about it; this too shall pass.

Our Love Song

When our hearts fell in love,
we began a journey
Together we traveled through valleys
and climbed mountains.
We watched sunsets and saw rainbows,
and weathered many storms.
Through the years we grew stronger
Together we learned to dream;
we overcame obstacles
Our love whispers our story.
While some fairy tales may end,
Our love song will be sung
and will last forever.

Only Passing Time

The first time we touched, I can barely explain.

It felt like a lightning strike during a spring rain.

Your tender touch became the sweetest drug.

I long for it, desire it, need your gentle hug.

Lonely, sleepless nights, I dream of your arms around me.

Gazing into your eyes, as you wonder what I see.

I love sharing your secrets, listening to stories you tell.

Holding you, watching you breathe, and the way you smell.

Your love is a haven of warmth and desire.

Did you know this sensation sets my heart on fire?

Answers are disguised – only you have the key in hand.

Until the day I'll wear your gold wedding band.

For now there is no us, simply you and me.

Only passing time will tell, if we are meant to be.

Sending an "Air Hug"

My favorite time of day is early morning just before dawn. There are days when I'm up by 4:30 a.m. The stars still twinkle in the darkness of day, and sometimes I can see the Big and Little Dipper pointing their handles to other constellations in the sky. I sit alone...on the patio, listening to the stillness of morn.

The moon slowly fades away into the blue, cloudless sky, and the crimson sun rises in the east, warming the earth, drying the dew from the green grass and colorful flowers. Birds begin singing, bull frogs croak a good morning in their deep throaty voice. The village awakens . . . I'm not alone.

After I brew a pot of decaf, I feed the cat and dog. By now it's nearly 5:00 a.m., and George and I get ready for our morning walk. The village isn't quite awake, but cars can be heard traveling down the highway to their early morning destinations. It's a bit chilly this morning, as the humidity

hasn't reached its peak for a warm summer day. I grab a light jacket, stuff my pockets with the necessary doggie bags, and we are off for our mile and a half walk. Only a light breeze blows through my hair, but for the most part, my cap keeps my locks in place. George does his sniffling thing and spots a young rabbit. The gray rabbit is very quick and scampers ahead of us and waits. She plays this game to see how close we can get before she jumps into the high grass and cattails alongside the pond. I speak softly to George, "No, you can't chase it. She's faster than you." George wags his tail! Then I smile. We are *happy*.

In the early morning, I have a chance to think about the work I need to accomplish for the day. As usual, not everything will get done, probably by choice. I prefer to do other things outside than be stuck inside on a nice day. My thoughts turn to my family; they are busy trying to keep some normalcy with their families. Some of them are working from home with children underfoot; others are just working from home to social distance. They are alone, but together in that the whole world seems to be in a conundrum as to what to do. *Be sensible*, I say over and over. Be safe, stay home; but, we can't always stay home. Some companies need employees at the workplace. There are groceries to buy, doctor and dentist appointments to keep. *Be safe*, I say again.

A few times we've gotten together with our children and grandchildren; we social distance. It's not as much fun as it was last year when we could give hugs, eat meals together, **enjoy**, but we make the best of it. Just like the high five, we hug ourselves then spread out our arms to each and every family member…sending an 'air-hug.' We are together in the sense we can still talk and laugh, for laughter is the best medicine. I tell everyone to keep the faith; trying times like these build character and strength. Whether we are alone or together, do the best you can to overcome these circumstances, because it's an obstacle that can be conquered. Don't dwell on what you can't do, think about the things you can do. Like all pandemics throughout history, we must learn from them and move forward.

The Lord is My Shepherd

The Lord is my Shepherd: She guides me with an invisible hand, and gives me strength to change things I thought were impossible to change.

He makes me to lie down to rest: She told me to take time to smell the roses.

He leads me beside the still waters: So I may drink of Her countenance and appreciate this precious commodity.

He restores my soul: She shows me the path to forgiveness, love, and understanding.

He leads me in the paths of righteousness: She gave me a voice for the sake of all women who are oppressed and downtrodden.

Though I walk in the valley of the shadow: She gives me strength to endure hardships and to appreciate prosperity with a humble heart.

Yes, I know He is with me: She empowers me to keep an open mind and seek knowledge.

He prepares a table before me: So that I may share my bounty to feed the hungry.

I am anointed with oil and my cup overflows: She helps me understand that change happens from within.

Surely goodness and mercy shall follow me: It is in giving that I receive Her blessing.

I will dwell in the house of the Lord: I know She is with me all the days of my life.

Changing Seasons

The cool, crisp autumn weather brings back memories of my mother-in-law Millie's kitchen and her art of canning. In spring, she would eagerly plant her vegetable garden. As spring drifted into the warm days of summer, she and Daniel, my father-in-law, worked day after day weeding the garden and fertilizing the tender plants, trimming apple and pear trees, pruning the raspberry patch, and waiting with quiet anticipation for the fall harvest.

I could always tell when canning season was upon us by the aromas that greeted us at the entrance to her breezeway door. I can still hear her cheerful "Well, hello, come on in" as she hustled and bustled around the kitchen. She made coffee in an old aluminum coffeepot on the top burner of her gas stove. I think the slow cooking method helped keep the coffee bean scent in the air.

I wanted to learn to can fruits and vegetables. At first I was a spectator, watching a master at work. Her kitchen always held the fragrant whiff of home-baked goods like kuchens, pies, applesauce, and tomatoes. The sauces simmered on her stove or desserts baked in the old gas oven. These fragrant bouquets made your taste buds go wild. Through the years, she taught me her secrets. I was a patient student, learning a masterful art.

When canning season was in progress, she worked from dawn to dusk. Around mid-August, peaches were ready. She liked to use the Colorado peach because of its juicy, sweet taste and beautiful golden, red-ripened skin that came through on the inside of the peach. She would buy a crate or two and feverishly set to work, washing the jars by hand (she never had a dishwasher), preparing the light sugary syrup, readying the canning kettle, and then dipping the peach in scalding hot water to remove the skin. She worked quickly, slicing the delicate fruit, pouring the hot syrup mixture over the slices, and sealing the jars with a hot Kerr lid and ring. It was important to prepare each jar individually to prevent the peaches from browning. When there were seven pints ready, she would put them in the canning kettle to process the jars. Soon the timer rang, and it was time to take the

jars out of the canner. You could see the golden peach slices simmering in the hot bubbling juice as they were placed carefully on the wooden board to cool. After cooling, the jars were labeled and stacked in the fruit cellar on the shelf.

Pickles were the next delicacy she canned. She would go into the garden early in the morning to pick the freshest cucumbers. Then she scrubbed the cukes with a vegetable brush to remove the prickly spots, cutting the larger cucumbers into wedges or slices. She placed a head of dill in the bottom of the quart jar and proceeded to add the sliced cucumbers. When the jar was full, she put smaller pickles on top and finished with another head of dill. Meanwhile, the kitchen would be filled with a pungent odor of boiling vinegar, water, and salt mixture. Before sealing the jars, she would slip a piece of alum inside each quart. The alum was used to keep the pickles firm during the canning process. The canning kettle was set to boil and the quart jars were placed inside for about ten minutes. This recipe was called "overnight dills" because you had to wait at least twenty-four hours after processing the pickles to be able to enjoy the first taste.

The harvest was well underway. Tomatoes were ripening fast on the vine. The warm, humid weather of summer provided an excellent growing environment. She used 'Better Boy' tomato plants because they were the meatiest and juiciest for canning.

One particular day, my mother-in-law gave me my own copy of her infamous canned barbeque sauce recipe. This recipe had been in the family for four generations. I felt like I received a treasured antique. The list of ingredients was long, and my supply list grew. If I wanted to begin canning, I would have to buy all the necessary supplies to get started. The initial expense was costly because I didn't own a canning kettle, food mill, pint or quart jars, or canning rings and lids. As I scanned the list, I made note of the special spices that would also have to be purchased on my shopping trip. Let's see, cinnamon, cloves, allspice, dry mustard, apple cider vinegar, brown sugar, white sugar, chili powder, and salt. So these ingredients were the result of Millie's tasty barbeque sauce! As I read the instructions, I figured I could easily duplicate the sauce and went to purchase my supplies. Little did I

know there was a lot of work involved in this process. I arrived home and went straight to work. I began washing the jars. I didn't have a dishwasher back then, so washing the jars took a long time. I had to make sure they were rinsed and sterilized. Millie gave me a bushel of tomatoes from her garden. This was more than enough for my first endeavor in canning. I washed the tomatoes, dipped them in boiling water to remove the skins, and cut them into chunks. I added the apple cider vinegar, sugar, spices, green peppers, and diced onion. Oh, how the diced onions made my eyes water. I set the kettle on the burner to slowly simmer. As the mixture came to a rolling boil, a breeze drifted through the kitchen window and swept the fragrant aroma of cinnamon, allspice, cloves, tomatoes, and apple cider vinegar throughout the house. After the sauce boiled for thirty minutes, it was put in jars, sealed with the canning lids and rings, and processed in the canning kettle. Soon I was able to fill my fruit cellar with the bounty of my summer crops.

I enjoy canning to this day. While there are similarities in my canning and my mother-in-law's canning, there are differences as well. Technology has changed the comforts of my kitchen, and I have incorporated the use of a microwave oven and dishwasher to assist with the tedious aspects of preparing the liquids and washing the jars. I feel a sense of satisfaction that I am able to reproduce the same delicious canned barbeque sauce that's been in the family for generations.

Early one spring, I became overzealous and planted seventeen tomato plants. The *Farmers' Almanac* warned of a dry summer, and I was concerned that I would not have enough tomatoes to make the barbeque sauce, tomato juice, and tomato soup. I think I underestimated the amount of tomatoes that grow on a healthy vine. I ended up with five bushels of tomatoes! I was determined to can every single one, but by the end of the third bushel, I ran out of canning jars, ran out of energy, and gave the rest away.

That was the year I repaid Millie with a bushel of tomatoes from my garden. She wasn't able to work in her garden that year. While she had some difficulty getting around, she still used the same canning method that she taught me years ago. As I carried her jars to her fruit cellar, I could see the results of that year's harvest. I am thankful she had the patience and

understanding to help a new bride learn the art of canning. She is at peace, now, but I often think of her in autumn when the leaves turn golden, the tomatoes are red, and the green peppers are bright green.

So when your heart is sad, remember these words from John 14:27-29: "I am leaving you with a gift: peace of mind and heart. And the peace I give isn't fragile like the peace the world gives. So don't be troubled or afraid. Remember what I told you: I am going away, but I will come back to you again. If you really love me, you will be very happy for me, for now I can go to the Father, who is greater than I am. I have told you these things before they happen so that when they do, you will believe in me."

Family Treasurers

When my maternal grandmother, Ella Emma, passed away, it was a sad time for me. I was the oldest granddaughter and had the privilege of knowing this petite German woman. My fondest memory of Ella Emma happened when we took a bus ride to downtown Milwaukee. Grandma never learned to drive a car; she didn't need to because she lived in the city most of her life and became accustomed to riding the bus. One day, she took me downtown on a shopping trip. There were no department stores in the suburbs, so shopping in downtown Milwaukee was the only place she could buy clothing or pay her bills. I remember the building that is now called the 'Grand Avenue Mall'; it was a luxury office complex for attorneys and other businesses at that time. I can still hear my shoes clicking on the grand marble staircase as we walked up to the second floor.

We arrived downtown after a bumpy ride. My stomach felt queasy because I watched the telephone poles whiz past us; I always got car sick on trips anyway. Finally, the bus stopped, and we stepped down onto the sidewalk. Tall buildings surrounded us. The cool breeze that swirled around me made my stomach feel better. Soon, Grandma and I were busy running her errands. She went to the beauty shop and had her hair trimmed and, afterwards, stopped to pay some bills. We had a short wait for the bus to take us home, so we went into the Big Boy restaurant for a special treat. We entered the doors, and the clinking of cups and dishes and the roar of people talking all at once overwhelmed me at first. We sat at the counter and a waitress appeared. She wore a white dress with a ruffled apron and had her hair covered in a net with a funny cap on her head. A pencil stuck out from behind her ear. She reached to grab it to write down our order; but when Grandma told her that I would like a hot fudge sundae with a cherry on top and a coffee, the woman quickly put the pencil back in her ear. I remember the waitress sighing. She didn't write down our order at all.

When the waitress returned to the counter, she placed the most amazing fountain glass filled with ice cream, whipped cream, and hot fudge with a

large red cherry on top in front of me. My mouth watered at the sight of it. I never noticed that Grandma only sipped her coffee; she averted her eyes as I devoured the delicacy. I didn't know she only had enough change for one ice cream sundae; now that I think of it, I wished I would have offered her a taste.

We never traveled to downtown Milwaukee again. The years passed quickly, and when I turned nineteen, she passed away. My aunt gave me her Currier and Ives dishes as a remembrance (Grandma saved green stamps at the A&P store to get them), a black satin evening bag that had a Western Union pin from Grandpa, an empty gold compact that once contained her face powder, and in the box was a heavy wooden rolling pin that I still use today to make my delicious pies.

I'm fortunate to spend a fair amount of time with my grandchildren. I try to get down to their level so I can look into their eyes. We play games, tag and hide-and-seek; they listen to my stories and I sing songs. I hope I will leave them with fond memories of my visits. I want to teach them not to keep secrets, to tell their mom everything (because she will always be their protector), to be honest, and I pray that they will grow to become loving adults with integrity, strength, and wisdom.

Manatee

Oh Manatee
Gentle sea cow of the sea
How silently you swim
In the deep ocean of blue and green
Peace go with you
And be free

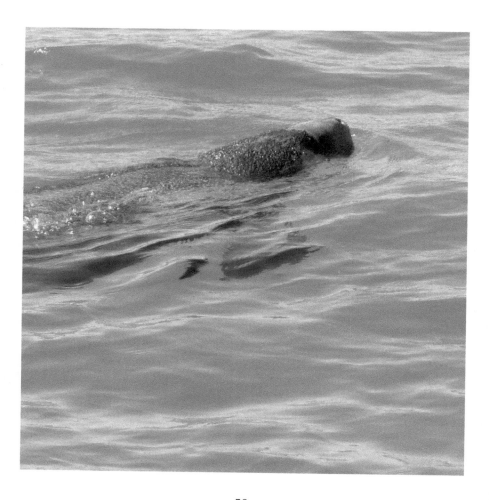

The Dream Inside

I came with a dream to find myself
the quest for learning was a secret locked deep in my heart

Somewhere I found courage to grasp the brass ring
a ring that once appeared unreachable

One small step turned into a leap of faith
with family guidance and encouragement I began my journey

When I turned the corner I stood in awe ahead in all its majestic glory,
I saw the Lannon stone tower of Notre Dame Hall
in reverence I stopped to listen and heard the bells tolling

The campus was surrounded by tall maple trees
shimmered with fall's colors of red, gold, and yellow
leaves rustled in the wind and branches swayed in the breeze.
It's like they were waving their autumn greeting
welcoming all who entered her doors

The music of laughing students caressed my ears
tears welled in my eyes.
Through these hallowed halls I strengthened my skills
professors became mentors and other students my friends

What began as a search for meaning nurtured the woman within
quickly blinking to conceal my excitement
afraid others would not understand,
how long I have waited to accomplish my plan

And soon I will walk down the aisle to receive my degree to the music
of Pomp and Circumstance.

I will leave behind this legacy that nothing is impossible

The Cave of the Heart

I wandered . . .
 . . . wandered, wandered
 for forty days and forty nights

Through the hot dry desert
 and
 the cold lonely nights

My strength is stretched to the limits
 I feel the beat of my heart
 Tears caress my paled cheeks
 Tired muscles throb with pain

I pause to listen to my breath
 a movement of air – *in*
 a movement of air – *out*

I find an Oasis
 a quietness calms my fears

I breathe in
 and
 I breathe out

A voice speaks softly . . .
 listening, I strain to hear
 the sound that's in my ear

It's a movement of air – *in*
 and
 a movement of air – *out*

I have wandered for forty days and forty nights
 and found a whispering God
 within the *Cave of the Heart*

Ties That Bind

Each year with the onset of winter, my heart clings to the warmth of autumn. And as each year passes, I am determined not to experience another cold winter. My heart silently takes flight to a warmer climate, a place called Florida.

Winter is my least favorite of Wisconsin's four seasons, yet I find that even plants and trees need rest from the rigors of the hot sun. Instead of viewing winter as a dreaded season, I try to look with interest at Mother Nature's ability to make a white blanket colorful.

All year long, our yard is a habitat for birds and small wildlife. The woodpeckers, cardinals, blue jays, and small critters are almost invisible when the grass is green and trees and bushes are filled with different-shaped leaves of varying color.

Only yesterday, two downy woodpeckers ate dinner at one of the suet feeders that's tied to the laundry post, while his cousin, the redheaded

woodpecker, a much larger species, pecked at suet by the other one. Every so often, gray rabbits and squirrels are seen scurrying over snowbanks to find a stash of food amidst the frozen ground, and if the eye is lucky to see, a hawk is circling above the yard in search of prey.

Three female cardinals pick at the seed in the bird feeder that sits outside the kitchen window. The female cardinals have beautiful olive-colored feathers. On occasion, the male cardinal, a dazzling red bird, makes his appearance. The blue jay squawks as he waits his turn to eat the dried sunflower seeds that are leftovers from the once brilliant yellow flowers of late summer and fall.

My heart turns toward Florida during winter. I long for the warmth of the sun and the sound of the waves crashing against the shore. My son and his wife live there, and I'm torn between living here in Wisconsin and being with them. Three daughters also live in Wisconsin. Two daughters have children—*my grandchildren*. Every so often, I'm asked to care for them. This is a blessing of grandparenting. Even though I long for sunny weather and the roar of the ocean, I take solace in the quiet of winter, of being where I am needed the most.

As another quiet snowfall fills the cracks and crevices of the earth, I think I would miss the colorful quilt that Mother Nature and Old Man Winter conjures up each day. There is an invisible cord that keeps me here; family are the ties that bind, at least for now.

Blossom

When I attended college, I took a class called "Philosophy of Love." Little did I know that this class would not be about deciphering love stories but learning about different cultures. It was a diverse group of twenty-seven female students. Our professor allowed us to openly discuss issues in the world as long as we respected each other's opinions. A young woman sat down, put her feet up on a chair, and crossed her arms over her chest. She looked angry, like she had an agenda or a bone to pick. She said, "I don't know why women in Africa are afraid to speak up." For a few moments, I sat silent, trying to collect my thoughts. I looked at my professor's face; he stood there and looked right at me, waiting for an answer.

My eyes rolled back in my head because I couldn't believe what I had just heard. I dreaded speaking my mind because I knew from past experiences that in mixed circles, my opinion might not be welcome. But this time it was different. Over the past few years, I had studied cultural anthropology and sociology and learned how other women lived. My mind raced to find a response. I realized it was important to think before speaking and wanted to make sure that my words would not offend anyone.

There was a young woman of Ethiopian descent sitting behind me. I glanced back to look at her and at the other students to see what their reactions had been. Our eyes connected. Her eyes widened, and she became very pale as her hand covered her mouth. The ghastly look on her face made it seem like the air had been sucked out of her throat. She knew that African women would be killed if they spoke up or refused advances from men, especially men who were not their husbands. You see, there were often tribal conflicts, and when other tribes invaded their communities, their men would be killed and they would be assaulted, or worse.

The silence in the room was so deafening that everyone could hear a pin drop. It took me another moment before speaking, trying hard to summon the courage to challenge this young woman. I sat up straight, planted my feet on the floor, and after releasing a deep sigh, I said my piece.

"Before I studied cultural anthropology and sociology, I would have agreed with your comment, but knowing the differences in cultures, I know that these women would have been killed." I went on to say, "There are women in our own country who don't have a voice." I paused a moment. "Women are abused every day for one reason or another." My professor stood there as I finished my comments. He put his hand to his chin and smiled.

My words silenced this young woman; she didn't offer any rebuttal and turned her head away. I don't know if this was a sign of respect or she simply realized that she had overstepped her boundaries by her denunciation of these women.

Afterwards, I looked back at the young Ethiopian woman; she mouthed a "thank you."

At this point, I knew that I had changed and grown into the person God wanted me to be. I found empathy. To keep an open mind is often difficult. Seeing both sides of the story is sometimes arduous but not impossible. Keeping silent in class would have been disastrous because there were many young women in that room who simply didn't understand that not all women are created equal.

Just the Right Blend of Potpourri

A few years ago, I had the opportunity to work in the same office as my husband. Everyone thought it would be impossible for spouses to work in the same place, but it did work out. He did his job, and I did mine. Only, I became very good at listening. As I worked on the opposite side of the cube, I often overheard his phone calls. He's a national support engineer and helped other people fix medical equipment over the telephone. It didn't take long before I began to understand why most nights he came home late; he simply couldn't hang up on a field engineer who worked to get medical equipment up and running in a hospital or clinic. They had families, too, who were waiting for them to come home. I soon understood why our communication was nearly void at night. He simply talked all day long and was tired.

From then on, my way of thinking began to change. I learned to be more understanding of his plight. Sometimes I had to throw red pepper flakes into the mix to be heard, but I learned over the years how to dry flowers and herbs to make our life a beautiful blend of potpourri. We accepted things we could not change and changed some of the things that needed changing.

In September 2011, my life was altered in ten seconds. While playing with our grandson, I slipped and fell, landing on my left hand. I instantly knew I had broken my wrist; the pain was excruciating. It would take over eight weeks to recover.

Later that morning, I left the hospital with my dominant arm in a cast just above my elbow. Over the next several weeks, I would become dependent on my husband. This was a difficult thing to do since I had learned to be very independent over the years. I soon realized the invisible *"S"* (for supermom) on my t-shirt had faded. I had to relinquish my wooden scepter to a higher authority, God. I had to learn to let go of my independence and depend on my husband. The doctor told me I shouldn't drive. *"What,"* I thought. I live in the country and relied on the car for everything. *"Now what!"*

Our world had been turned upside down by my accident. When I

worked in his office, I realized what he went through in a day. Now things were reversed, and he began to see how important I was in his life. My husband stepped up to the plate and really pitched in with errands, yard work, and the small everyday details that were often taken for granted by both of us.

Never once did he complain that he had to be my chauffeur. He became my important right-hand man. *(I previously held the title as the important but silent right-hand woman.)* He joked about it to make me feel better even though I could see the wear on his face. His job was still demanding, and now I added more to his burden.

I had a chance to watch every news program on television. There's not much to do with one arm except read, pass the dust cloth over the furniture, and take long walks. In our throw-away society, I noticed that people often complain and don't find a way to make things better. *We* had to rethink our way of cooking meals. I could hardly lift the kettle full of steaming broth, let alone cut the vegetables. He became a really good sous-chef. The only thing I could do was add the spices to improve the aroma of the soup. I think every couple should have to walk in the other's shoes to see life from a different perspective. Everyone knows, too much salt will spoil the soup. I'm thankful that we've found the right blend of potpourri to keep us going.

Gallstones and Milestones

We married during the time of the recession in 1971. My husband graduated from MSOE, and after months of sending resumes, he gained one interview with GE Medical Systems. He got hired about ten days before our wedding. That was cutting it close, but we wanted to be together no matter what. Our wedding day arrived on a windy April Saturday. The sun felt warm, and I remember my veil flowing in the wind like sheets that dry on clotheslines.

We settled into the small community where my husband grew up. Mostly because he was a volunteer firefighter and didn't want to give up helping others, especially in a farm community where they often had barn fires, grass fires, and house fires.

When we began to raise a family, both my husband and I decided that I would be a stay-at-home mom. The decision came with many hardships

because we would be living on one income. That meant a lifetime of doing without luxury items like boats, trips, cottages, new cars, and new clothes. But the benefits were as bountiful as the autumn harvest of fruits and vegetables. We raised four great children, all who attended college and found good jobs after graduation.

At an early age, the children were happy living in our old, drafty house. The house was set on just short of an acre of land. They had enough room to run, hide, and play ball. I can still hear their voices when they would play hide-and-seek among the tall sunflowers of yellow and gold that grew in our garden. At first, the yard only had one flowering crab apple tree, so we planted ten blue spruce and ten Black Hills spruce pine trees to line the perimeter of the yard. We added four Cortland apple trees and had enough apples each year to make applesauce, pies, and other desserts, and some left over to feed the horses that lived down the back road. Our yard had several flower beds and one very large garden. Each year we planted tomatoes, green beans, lettuce, squash, and pumpkins. When Halloween came around, the children pulled their red wagon by the vines to bring in the largest orange pumpkins for carving. Most of our friends had new, fancy homes, but our one-hundred-year-old house had character. It even had a resident ghost that made its appearance more than once. We didn't have to worry when visitors came that something would get broken. Our house always felt warm and welcoming.

I hadn't been feeling well and went to the doctor for a physical. He found out I had gallstones and they would need to be removed. Surgery wasn't one thing I wanted to happen with four small children. I scheduled surgery on a Friday so my husband didn't have to miss too much work. My family came to visit the next morning. Our younger daughter, Katie, smiled and said, "You're not going to be happy to see the stove. Daddy boiled over the Cream of Wheat and didn't clean it up right away." Everyone knows if you don't wipe up the spill of Cream of Wheat on a hot stove, that it will dry on very hard, almost like cement. I looked over at my husband and knew he had his hands full. Taking care of four children for one day was a daunting task for a mom, let alone a dad who wasn't used to the constant activity. I

always told the children that I knew what they were up to because I had eyes in the back of my head. My daughters liked brushing my long, brown hair, but they were afraid to brush the back of my head fearing they would hurt my eyes. I always chuckled about that. I don't think dads have eyes in the back of their heads, though.

I wanted to come home from the hospital that night, but something happened after they left. The hospital room had several beds in the ward. I happened to be the only patient. I watched as the nurse came and closed the door. I didn't know why she did that. In reality, I believed it was an angel making preparations for me to go to heaven. I began feeling very light-headed and quickly used the telephone to call my husband. I asked him to get in contact with the doctor because the nurse didn't come back to the room. I buzzed and buzzed the little alarm on my bed. But no one came.

After I hung up the phone, I felt my body begin to rise above the bed. I saw a bright light down a long tunnel. I pleaded with God that this couldn't be my time to go. My husband was home taking care of the children, and I didn't want to leave him alone. The Cream of Wheat incident convinced me that I definitely needed to remain an earthly body. I made a promise to God that I would do my best to become a better person. After a few minutes, the light in the tunnel became dimmer and the hospital room door opened.

The doctor came rushing and discovered that I was bleeding internally. He gave me a blood transfusion, and a couple days later, I went home.

My children never knew of this close call with death. I had made a promise to God that I would help people in any way I could if I could stay on earth, and He's held me to it all these years. My faith has brought me through many challenges.

We've watched our children grow into strong, confident adults. We are blessed with five grandchildren who are growing by leaps and bounds. We've witnessed the death of faithful animal companions who taught us about unconditional love. We've grieved the loss of our parents, siblings, and friends. While we've experience highs and lows in our life, every experience has been a stepping stone to something greater. Some of our steps were baby steps, and some were giant leaps of faith.

I believe there is a higher-power and when I watch for and listen to His signs, I find a peace that fills my heart with a quiet like the stillness of an early morning sunrise. I am thankful, grateful, blessed to have the love of an amazing husband and family. Our life's journey has been paved with many milestones; we are indeed fortunate to be together for so long.

(From left to right: Anna, Katie, Alison Matthew)

A Man Is Not a Towering Skyscraper

he's a tower of strength
dare he not weep
the secrets of life
held deep in his chest

bricks of mortar
pillars of steel
adjacent to the walls
for his country
his son
his daughter
his wife

his strong arms
holding on to life
guiding his family
to follow the sun
to walk along the path
to be honored and respected

A Tribute

Autumn has always been my favorite season even though it seems to be the shortest of the four seasons in Wisconsin. My husband asked me to marry him on my September birthday, and of course I said yes. He still attended MSOE in Milwaukee and had one semester left. He went back to school, and I started planning our wedding for the following April. I worked as a technical publications secretary at local farm implement company. I made $1.75 an hour and wondered how we would pay for our wedding. It all worked out, though.

He graduated in January of '71 and searched for a job. A recession hit that year, and it took him four months and seventy-five resumes when he received a job offer from GE Medical Systems. My husband, Adrian, worked for the company for over forty years. He held many positions, but with each change, he learned about medical equipment and became a National Support Engineer, fixing X-ray equipment and helping troubleshoot other issues as well. He worked long, hard hours, and he seemed to be on call almost 24/7. His job was anything but an eight-hour job. Most days, he arrived home later than six at night and oftentimes missed family meals and soccer games because the phone call he was on had major problems. His job took him all over the United States, and to Italy.

When he wasn't working, he became Dad. He was a darn good dad, too. He liked watching our children play soccer and tennis. He taught our son how to hunt safely, and attended band concerts and high school football games so we could watch the band play halftime shows.

In his spare time, he was a volunteer firefighter. The St. Lawrence Fire Company had approximately thirty men who came from all walks of life. Some of the men were farmers and were able to get to the fire calls quicker than most men. Other people had jobs outside of the area. If the fire company received a call for a large fire or mutual aid, sometimes my husband would leave work to assist at the calls. His company had a policy that allowed this to happen.

It never became easy to wake up from a deep sleep during the night to the piercing sound of the pager's alarm. Barn fires were prevalent in the early years as hay had been stored in the hayloft. As my husband hurried to get dressed, I ran to get the car keys, turn on lights, and sometimes start the car so he could get in and go. We owned a scanner, but I tried not to listen to it during those calls. It was stressful enough to wait, sometimes hours, for his return. Thankfully, he always came back home to his family. His clothes had to be washed several times to get the acrid smoke out of them.

For fifty years, I've watched the fire company evolve from a men-only membership to both men and women, who were not only firefighters but became first responders. This is how he became a volunteer firefighter:

When he was twenty years old, he attended his first call with his dad. Daniel drove the 1953 Ford Pumper and Adrian rode shotgun to a barn fire. When he jumped out of the pumper, someone handed him a flashlight and told him to get to the barn and shine the light inside. The firefighters were trying to get the tractors out of the barn and the gas lines shut off. The fire intensified and smoke thickened. His eyes were tearing and his lungs burning from inhaling the smoke. (He didn't have turnout gear or a face shield at that time.) He looked at the flashlight shining two feet in front of him and decided he wasn't doing any good and backed out of the smoke; however, there was something in the swirling smoke that night that permeated his clothes, and his spirit. That's when he became a true smoke eater; once a firefighter, always a firefighter. After thirty-one years of service, he became an honorary member of the fire company. About seven years later, he turned in his pager when we moved outside of the community. A few years after he retired, he was honored for fifty years of service. Adrian always maintained his status as a volunteer and helps each year with the St. Lawrence Fire Company's annual firemen's picnic.

All good things must come to an end. I can't say it's easy to give up something you enjoy being a part of all your life. Adrian's farewell speech:

"The years went by pretty fast. There was a time when I was taking part in a chimney fire drill. I was in full turn-out gear and had an air pack on. I climbed the ladder to the roof and then climbed the roof ladder to the

peak to straddle the peak. I shuffled along the peak toward the chimney. My hips were already starting to ache. I sat there for what seemed like just a few minutes debating whether or not to crack open the bypass valve and get a blast of air so I could catch my breath. Shortly after, a low air alarm bell started going off, and I wondered who was running out of air. Then the rest of the crew started looking at me and I realized it *was* me. I climbed back down to the ground while the rest of the crew kept working up on the roof. That's when I realized it was getting harder to handle the physically demanding parts of the job, and thoughts of retirement from active service chimed in my head. At the same time I thought of retirement, I wondered who would carry on in my place. It didn't take long, and I came to the conclusion that they already had a solid core of dedicated young men and women here and another fine group of young men and women had just come on board. It made me feel good knowing that the traditions started in this community in 1904 and 1991 would carry on. I became an honorary member in 2000 after thirty-one years of active service and then finally turned in my pager in 2013 when Kathy and I moved away. I am very proud that this organization, in a small community and with limited financial resources, kept up the tradition over the years with upgrades to vehicles, firefighting and rescue equipment, breathing apparatus, and personal protective equipment. They are as well-equipped and trained as any major full-time city department. So in closing, I would like to thank you my brothers and sisters for bestowing these honors on my 50th anniversary of service to the St. Lawrence Fire Company."

Some of his fellow firefighters had tears in their eyes after Adrian's speech. I admittedly cried when he turned in his pager to the fire chief. The fire company had been a part of our life for so long.

Over the years, he witnessed the death of a friend's son and several men who were on their way to a fishing trip on local highways. Through all of this, he's remained constant. He left a legacy for others to follow to be dependable, brave, strong, trustworthy, a true and honest friend, wonderful husband, father, and grandfather. He is my hero.

They Call Me Nana

When I attended college in my early fifties, I had high hopes of finding a new job. My dream of earning a bachelor's degree came to fruition after four and half years, and a career move seemed promising. To my disappointment, such a career move didn't happen. After graduation, the economy suffered a recession. It seemed we often experienced recessions throughout our life. Now I faced being jobless, and repayment of college student loans loomed over my head.

When our children were in high school, I worked for many years as a part-time contract Administrative Assistant. Working as a contractor afforded me the opportunity to choose my hours. I brought in good money but never viewed these jobs as a career. For the most part, the extra money came in handy to pay for the necessities of life and to help our children in college.

The Internet became a great resource in the job search, but it also became a detriment because employers could find out my age. Now that I had a college degree, I either became over-qualified or my age became a factor. Ageism seemed like a myth only a few years ago, and I soon realized that no one would hire a woman who had turned sixty. I had reached the glass ceiling, and many doors closed. Not really wanting to work for minimum wage at Mickey-D's or any other fast food place, I decided to throw in the towel and retired early, especially considering the current economic climate.

After high school graduation, I worked as a file clerk, married and became a mom (priding myself in my domestic engineering capabilities); I went from full-time mom to part-time Administrative Assistant when the children went to college. Then after all the children graduated from college, I attended college and worked as a part-time Technical Writer, finally coming full circle to being a domestic engineer with a college degree.

That spring, my husband and I celebrated our fortieth wedding anniversary. Since graduation, I wanted to find a job, a real job so that we could take a honeymoon when he retired. We never took one when we were married because of the recession that year.

We married in April 1971 and had two days to get settled as husband and wife, a new beginning with many uncertainties. We didn't have credit cards and bought things on ninety days, same as cash. I worked full-time until the children entered the picture. That's when I became a stay-at-home mom. Living in the country also factored into that equation; as the children grew and entered middle school, they became involved with band and sports. They needed someone to drive them to and from their activities. I became the 'go-to mom' for snacks at school, room mother, and pasta parties the night before soccer games. They were busy days that went by way too fast.

Forty years ago, it didn't really matter if we took a honeymoon or not. What really mattered is that we had jobs and worked very hard to become established. We learned to do without so that I could stay home with the children. "Make it last, do without . . ." became our mantra.

Now, I'm not quite sure if we will take a honeymoon to Ireland when my husband retires. Not finding a job put a monkey wrench in those plans, but then, not having luxuries is nothing new. We may only travel as far as Door County, one of our favorite vacation spots. My most cherished blessing is when I became a grandmother. Each day I am rewarded with hundreds of kudos from smiling faces that I never received in any paying job. My grandchildren call me "Nana."

When Nature Calls

A few years back, while raking autumn leaves of red and gold, a young black-and-white kitten visited the yard. He seemed friendly, sitting on the bench beneath the old maple tree. I tried to ignore him; cats were not a pet my husband preferred in the house. I finished raking for the day and went inside. Little did I know that Mother Nature would whisper in my ear; she told me that this kitten needed a warm home. I tried to ignore her voice, but the next day, more leaves fell, and once again I found myself outside raking up mounds of leaves when the black-and-white kitten reappeared. He purred sweetly, this time twisting and turning around my ankles. It didn't take long before I sat on the bench and he jumped into my lap. By midafternoon, the air temperature had dropped from the high 40s to low 30s. Winter was looming in on us. Outside animals were in peril of freezing.

That night, I brought him in the basement. I put a litter box in the corner, water and cat food in a dish next to the box. I went upstairs and pretended everything was fine; my husband didn't care for cats, and I knew I'd have some explaining and coaxing to do to save this kitten from winter's frigid temps.

I gave myself away when I went downstairs one too many times to check on the kitty. My husband knew I had rescued it, and he was displeased. We argued. I cried, "But this kitty will die outside." My tears fell on deaf ears. Reluctantly, I put the kitten outside for the night. We went to bed without saying another word. In the back of my mind, I knew what I had to do. After all, I had great maternal instincts. If I could, I would save all the frogs, birds, cats, rabbits and other creatures that needed help. I would do it in a heartbeat.

During the night, the temps dropped way below freezing. It was late November; the warm days of autumn had suddenly come to an end. After

my husband went to work, I went outside and called for the kitten. "Kitty, kitty," I said tearfully. I must have searched for him for an hour. Just when I was about to give up, he appeared next to the house. I called softly to him, again. But he stood next to the building as if he were upset with me. He sneezed. I rushed over to pick him up. Surprisingly, he didn't try to run away. I nestled him in my sweatshirt, speaking soft words in his ear, and we went inside the house. "Poor kitty," I whispered.

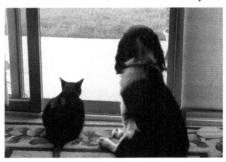 Our dog accepted the kitten right away; now I had to get my husband to accept the fact that we were going to have another four-legged animal to share our abode, and a cat at that. The hours ticked by, and before I knew it, the day had ended. I had prepared an extra special meal and set the table with candles in hopes to soften him up. When he looked at me, he knew. "You brought the kitten in, didn't you?" He knew me so well.

After serving a warm dinner, I brought the kitten upstairs. "Isn't he cute," I cooed. I never thought a kitten would bring so much joy. My husband only shook his head. He knew he had lost the battle, but I feel we both won because I was happy to have rescued this animal from the cold. My husband had nurtured my spirit. Now fifteen years later, this lovely tuxedo Tom-cat has passed onto the Rainbow Bridge. Morgan was sweet, aloof, and gentle. He loved kisses on the top of his head. When he needed warmth, he sat in front of the fireplace until I turned it on. I will forever miss his soft purrs and the pitter patter of his feet. He taught me that if you are kind to your animal companions, they will give you unconditional love. Morgan, you left your paw prints on my heart. I will always love you.

Winter's White Shawl

Earth is sheltered in winter's white shawl
green grass is hidden under the snow

Red cardinals and chickadees warmed by the chimney
perched on the pipe of the old wooden stove

A warm fire crackles and sizzles
filling the house with an applewood scent

Sipping hot chocolate, I snuggle beneath the patchwork quilt
dozing contently, with the cat on my lap
subconsiously preparing for a long winter's nap

Acknowledgements

When the pandemic arrived in Wisconsin, I became concerned for the health and well-being of my family. The COVID-19 virus is probably the worst thing that could happen to the world. We had to learn a new way of life, and for some families, it became difficult because of age and health reasons, social distancing from family and death. History tells of other pandemics, and we need to understand "this too shall pass," as will all challenges in life. We need to become united in our struggles.

I am sincerely grateful to my family for their support. To my husband, Adrian, the love of my life, we've been through highs and lows, but our love has remained constant. You are my best friend. Thank you for supporting me through college and for encouraging me to become a Reiki Master. I am thankful for my children: Alison, Matthew, Kathryn, and Anna. I'm so proud of your accomplishments. I am blessed with five grandchildren: Lauren, Evangeline, Brendan, Nolan, and Colin. I love all of you. To my godmother, Auntie Joan, you mean the world to me. You have inspired me to keep writing.

I'm fortunate to write short stories under the pseudo-name of my grandmother, Ella Emma, for the Wisconsin Rural Women's Initiative, and to be a published poet in the 2005 Wisconsin Poet's Calendar.

My life's journey has been filled with stepping stones that turned into milestones through perseverance, determination, and stubbornness. When the going got tough, I took a break, asked for advice, used prayer and meditation to get me through to a new day. I became an amateur photographer because what I see through a camera's lens is priceless, and sometimes when I print a picture, I realize that words are not needed. I enjoy writing and hope you enjoy reading my poems and stories. May your life's journey be filled with happy memories.

Appendix

The following stories were printed in the Wisconsin Rural Women Initiative Newsletter under my pseudo-name, Ella Emma.
- "A Picture is Worth a Thousand Words" (Summer 2020 Blog)
- "Chasing the Moon" (they used the wrong title; title should have been: "Capturing the Moon") (Summer 2020)
- "This Gift I Give" (Winter 2019)
- "Of Cocoons and Butterflies"
- "A Basketful of Eggs" (November 2012)
- "Sending an Air Hug" (Fall 2020)
- "And then…Snow in December"

Wisconsin Poets Calendar 2005
- "Winter's Cold Wind"

Kathleen Krebs, married to Adrian; mother of four children, Alison (Scott), Matthew (Carey), Kathryn (John) and Anna; five grandchildren Lauren, Brendan, Evangeline (Alison and Scott), Nolan and Colin (Kathryn). Pet mom to my sweet George, an English springer spaniel, and my sweet black and white tuxedo cat, Morgan who has crossed to the Rainbow Bridge; pet grandmother to Tiggy, Daisy and Wilson. I'm a writer, an amateur photographer, love gardening, nature and baking.

CPSIA information can be obtained
at www.ICGtesting.com
Printed in the USA
BVHW060101160721
611886BV00003B/72